FOUNDATION
DESIGN

FOUNDATIONS OF
DESIGN

JEFF DAVIS

WADSWORTH
CENGAGE Learning

Australia • Brazil • Japan • Korea • Mexico • Singapore • Spain • United Kingdom • United States

WADSWORTH
CENGAGE Learning

Foundations of Design
Jeff Davis

Publisher: Clark Baxter

Development Editor: Kimberly Apfelbaum

Assistant Editor: Ashley Bargende

Editorial Assistant: Liz Newell

Associate Media Editor: Kimberly Apfelbaum

Marketing Program Manager: Gurpreet S. Saran

Senior Content Project Manager: Lianne Ames

Senior Art Director: Cate Barr

Senior Print Buyer: Mary Beth Hennbury

Rights Acquisition Specialist, Image: Amanda Groszko

Production Service: Integra

Text Designer: Nilou Moochhala, Nymdesign

Cover Designer: Nilou Moochhala, Nymdesign

Cover Image: *rectangle study 16* © 2011 Jeff Davis

Compositor: Integra

For product information and technology assistance, contact us at **Cengage Learning Customer & Sales Support, 1-800-354-9706**

For permission to use material from this text or product, submit all requests online at **cengage.com/permissions** Further permissions questions can be emailed to **permissionrequest@cengage.com**

Library of Congress Control Number: 2011930223

ISBN-13: 978-1-111-34361-3

ISBN-10: 1-111-34361-6

Wadsworth
20 Channel Center Street
Boston, MA 02210
USA

Cengage Learning is a leading provider of customized learning solutions with office locations around the globe, including Singapore, the United Kingdom, Australia, Mexico, Brazil, and Japan. Locate your local office at: **international.cengage.com/region**

Cengage Learning products are represented in Canada by Nelson Education, Ltd.

For your course and learning solutions, visit **www.cengage.com**

Purchase any of our products at your local college store or at our preferred online store **www.cengagebrain.com**

Instructors: Please visit **login.cengage.com** and log in to access instructor-specific resources.

Printed in the United States of America
1 2 3 4 5 6 7 15 14 13 12 11

ations of Design is a straightforward examination of the
ples of two-dimensional design. It introduces the basic elements
sign, investigates their defining qualities, and explores possibilities
heir compositional organization. The information is provided in
ear fashion, with each new chapter building on the previous. In
end, *Foundations of Design* strives to present a framework for
derstanding the construction of a composition and is meant to be
cessible to anyone with an interest in two-dimensional design.

CONTEN

PRE

Found
princ
of de
for
a li
th
u
a

CONTENTS

PREFACE

Foundations of Design is a straightforward examination of the principles of two-dimensional design. It introduces the basic elements of design, investigates their defining qualities, and explores possibilities for their compositional organization. The information is provided in a linear fashion, with each new chapter building on the previous. In the end, *Foundations of Design* strives to present a framework for understanding the construction of a composition and is meant to be accessible to anyone with an interest in two-dimensional design.

ACKNOWLEDGMENTS

I would like to sincerely thank everyone who helped make this
book possible.

To Kimmy, Clark, and the entire team at Cengage Learning for your
guidance and direction.

To the Helene Wurlitzer Foundation of New Mexico for your gift of time
and space.

To Kevin Appel, Tim Bavington, Lisa Beck, Ginny Bishton, Alex Brown,
Gary Andrew Clarke, Chuck Close, Verne Dawson, David Deutsch, Peter
Doig, Lecia Dole-Recio, Pierre Dorion, Thomas Eggerer, Bart Exposito,
Andreas Gursky, Chris Hanson and Hendrika Sonnenberg, Mamie Holst,
Mustafa Hulusi, Jim Isermann, Craig Kalpakijan, Bob Knox, Bill Komoski,
Robert Koons, David Malek, David Moreno, Sarah Morris, Ann Pibal,
Joseph Podlesnik, Ruth Root, Alexander Ross, Luke Rudolf, Peter Saul,
Dirk Skreber, Philip Taaffe, and Aaron Wexler for your creativity
and consideration.

To my parents for the freedom and encouragement to pursue
my dreams.

To Rob and Ryan for your endless curiosity and inspiration.

And to Kelly for your unwavering love and support.

ABOUT THE AUTHOR

Courtesy of Tyson Crosbie

Jeff Davis currently serves as the program director for the Foundations Department at the Art Institute of Pittsburgh—Online Division, where he leads faculty and curriculum development. Prior to his role as program director, Jeff served as a faculty member for AiPOD, teaching Fundamentals of Design and Color Theory. He is also a practicing digital artist and has exhibited his work throughout the United States. Jeff received his BA degree in Mathematics and Studio Art from Lawrence University and his MFA degree in Painting and Drawing from the School of the Art Institute of Chicago. He currently lives in Tempe, Arizona, with his wife and two children.

For more information, please visit: http://www.jeffgdavis.com

DESIGN

01

01 DESIGN

The word design is both a noun and a verb. It is an activity and a product, a process and a result. There are numerous books on the subject of design, and each provides its own definition of what the concept of design means. Many words arise during this discussion, words like plan and organize, purpose and intent. The artist and educator, Josef Albers wrote:

> *To design is*
>
> *to plan and to organize, to order, to relate and to control.*
>
> *In short it embraces*
>
> *all means opposing disorder and accident.*
>
> *Therefore it signifies*
>
> *a human need*
>
> *and qualifies man's*
>
> *thinking and doing.**

This suggests the act of designing is a decisive one, where nothing is left to chance and the result is deliberate. As a verb, to design is indeed to plan or intentionally create. As a noun, a **design** is the conclusion of this plan, a resulting product with a given purpose.

The design process can also be thought of as an act of problem solving. A designer seeks visual solutions to specific situations, whether those situations are self-prescribed or provided by someone else such as a client. In this sense, a design is an answer to a visual problem. But for this

* François Bucher and Josef Albers, *Despite Straight Lines*. (Cambridge, MA: MIT Press, 1977).

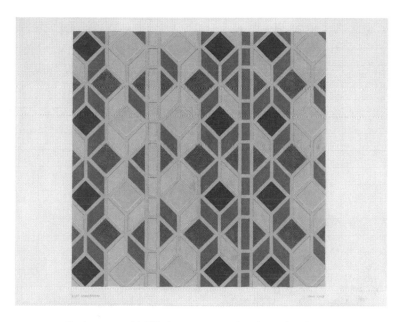

DESIGN. Jim Isermann, Untitled 1303, 2003. Colored pencil and pencil on graph paper, 17 x 22 inches (43.2 x 55.9 cm). © Jim Isermann. The Judith Rothschild Foundation Contemporary Drawings Collection Gift. The Museum of Modern Art, New York, NY, USA. Digital Image © The Museum of Modern Art/Licensed by SCALA/Art Resource, NY.

answer to be effective, the designer must utilize a visual language and understand the many correlations between its elements. While there are no specific laws for the application of this visual language, guiding principles do exist that can help a designer generate a successful solution. As the creative process moves forward, a designer can use these guidelines to consider each visual relationship and evaluate its need and its worth. Certainly, a designer can work without a conscious awareness of these principles and develop an effective result through more intuitive means. But in most cases, understanding the elements of the design language and their interactions with one another will help the designer obtain an efficient and successful result.

Once a design is completed, it will necessarily communicate something to a person who is viewing it or experiencing it. This communication occurs in a language that is visual rather than verbal. The resulting information passed along to the viewer can be divided into two parts: the content of the design and the form of the design. The content of a design is its subject matter. It is the story or the information that the design wishes to convey; it is what the design says. Form, on the other hand, is the purely visual impact of a design. It is how the visual elements are manipulated and organized; it is the way the design looks. While both are equally important in the creation of a design, the primary emphasis of this text will be on the latter. The focus will be on the formal qualities of a design over its content, not exploring what is being said, but rather how it is being said.

FORMAT

02

02 FORMAT

All designs inherently begin with an empty space of some size and shape. A designer needs a receptacle in which to execute a design, and this defined space is called the **format** of the design. It is where the visual elements of a design are placed and arranged. Depending on the type of design being created, this could be a three-dimensional space, but for the purposes of this text, we will consider the format of a design as a two-dimensional surface with a specific height and width.

Before beginning any design, the first step is to decide on the size and shape of its format. This decision can have a great impact on the way a design is interpreted and should be considered carefully. A large format delivers a much different effect than a small format. Large formats tend to be bolder and more aggressive, while smaller formats create a greater sense of intimacy and individual connection (2-1). The shape of the format can also greatly affect the mood of a design. Rectangular formats are traditional and generally convey a sense of stability. A rectangular format with a vertical orientation is known as a **portrait format**, while a

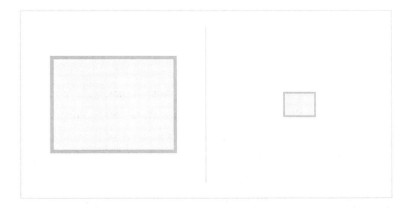

FIGURE 2-1

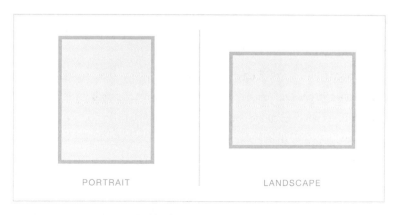

PORTRAIT LANDSCAPE

FIGURE 2-2

FIGURE 2-3

rectangular format with a horizontal orientation is known as a **landscape format** (2-2). On the other hand, a format that is non-rectangular can create an impression that is more active and dynamic (2-3). So careful thought must be given to the overall parameters of the design before the design is even started. Once the format is established, the designer can begin to assemble the elements that will ultimately compose the design within.

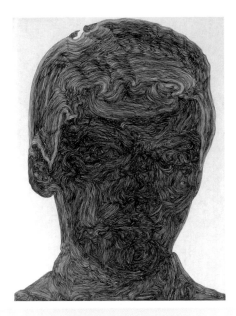

PORTRAIT FORMAT. Alex Brown, **Fingerprince**, 2000. Ink on paper, 30 x 22 1/2 inches (76.2 x 57.2cm). © *Alex Brown. Courtesy Feature Inc., New York. Museum of Modern Art, New York. Judith Rothschild Foundation Contemporary Drawings Collection Gift.*

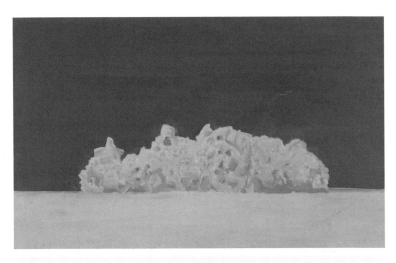

LANDSCAPE FORMAT. David Deutsch, **Untitled**, 2011. Oil paint on linen, 24 x 36 inches (61 x 91.4 cm). © *David Deutsch. Courtesy Feature Inc., New York.*

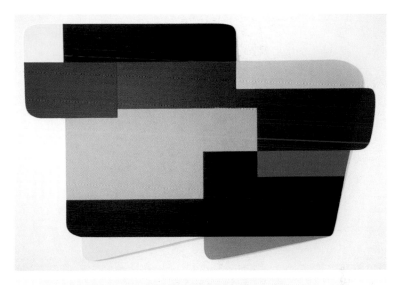

NON-RECTANGULAR FORMAT. Ruth Root, Untitled, 2007–2008. Enamel on aluminum, 60 1/2 x 84 1/2 inches (153.67 x 214.63 cm). © Ruth Root. *Courtesy of the artist and the Andrew Kreps Gallery, New York.*

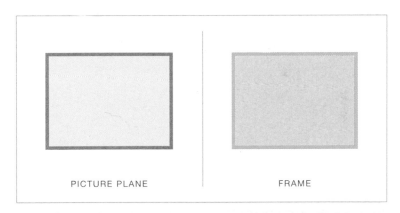

PICTURE PLANE FRAME

FIGURE 2-4

Every two-dimensional format consists of two distinct parts: the picture plane and the frame (2-4). The **picture plane** is simply the flat surface on which the design is executed. It is a two-dimensional plane where the

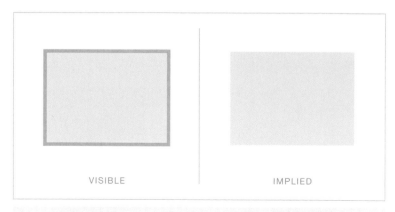

VISIBLE IMPLIED

FIGURE 2-5

elements of the design reside and interact. The boundaries or edges of the picture plane comprise the **frame** of the design. The frame is the border that specifies the outer limits of the design from the space surrounding it. If a line of some width is physically drawn around the perimeter of a design, then the frame is visible and a distinct element of the design. If the design is simply contained within a given area without the outer edge being demarcated, then the frame is implied and not a distinct element of the design (2-5). In either case, careful consideration should be given to the relationship between the frame and the design within.

LINE

03

03 LINE

Of all the visual elements in design, line is perhaps the most familiar and recognizable. The concept of line is so basic to design that it is difficult to envision a design as having no lines. Lines provide a very fundamental way of conveying information and are often the elements first considered when executing a design.

A typical definition for line is the path traced by a point moving through space. This is a useful conceptualization because it conveys the inherent sense of motion that a line possesses. But for this definition to truly make sense, we must come to an understanding of what constitutes a point. A point is defined as a precise location in a two-dimensional space. In a theoretical sense, a point has neither length nor width. But in order for a point to be visible, it must possess some measure of length and width. In general, we think of a **point** as a very simple form that has roughly equal length and width and is relatively small in size (3-1). Then as a point moves across the picture plane, its path becomes a line (3-2).

FIGURE 3-1

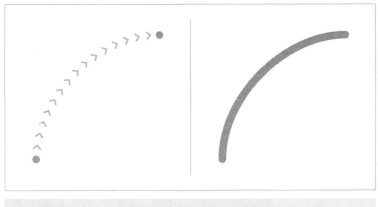

FIGURE 3-2

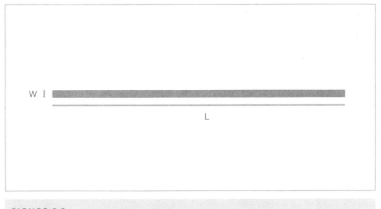

FIGURE 3-3

We may also define a line as a one-dimensional element described by its length, but having no width. This is also a useful conceptualization because it conveys the inherent sense of direction that a line possesses. But this definition of line is a purely theoretical one. For a line to be visible, it must have some measure of width to accompany its length. So, we generally recognize something as a **line** when its width is relatively narrow and its length is prominent. It is this visual comparison between the thin width and the prevailing length that gives a line its character (3-3).

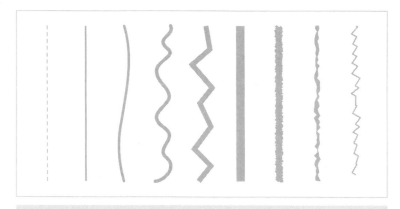

FIGURE 3-4

Once we understand this relationship between a line's width and its length, we find that it is capable of endless variety (3-4). Lines can vary in width, which is also known as **line weight**. A line with a thick width is said to be heavy, while a line with a thin width is said to be light. Lines can also be long or short, with differing effects created by varying lengths. The path a line follows additionally affects the way it is read—whether it is straight or curved, fluid or jagged. Even the relationship between the two edges of a line can be adjusted, making it appear smooth or irregular, sharp or fuzzy. All of these possibilities give the designer a large working vocabulary for line, with each variation bringing its own unique personality to the image.

Like the frame of a design, lines can also be actual or implied. Thus far our discussion has dealt with the idea of visible lines, those that can be seen in a design and have a physical presence. But because of the elementary nature of line in our visual language, we often see lines that are not actually present in a design. These apparent lines where none physically exist are known as implied lines. For instance, a series of points or shapes that all follow the same path are often visually grouped together to read as

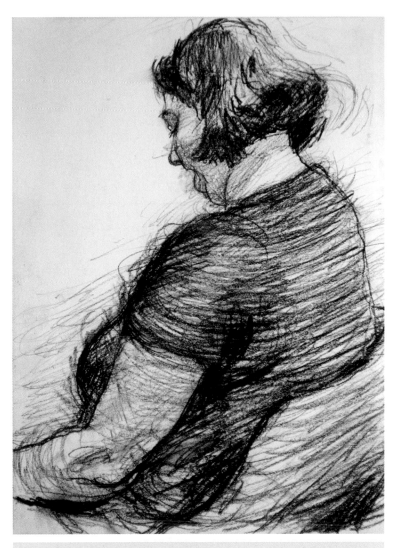

LINE VARIETY. Joseph Podlesnik, **Seated Figure,** 2009. Conté crayon on paper, 8.75 x 11.5 inches (22.2 x 29.2 cm). © *Joseph Podlesnik. Courtesy of the artist.*

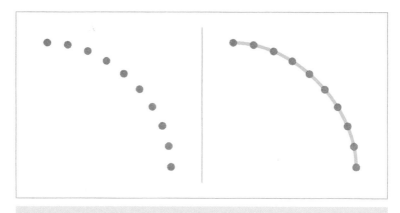

FIGURE 3-5

FIGURE 3-5

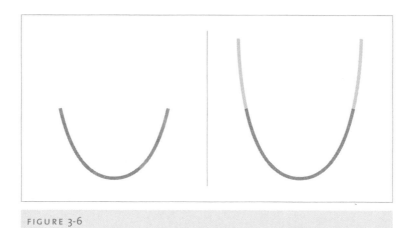

FIGURE 3-6

a line (3-5). Also, we tend to extend lines moving in a certain direction, again mentally creating paths in the design that are not physically there (3-6). When there is some connection between two or more elements in a design, we may also psychologically connect those elements with an implied line (3-7). Even when a line is not visually present in a design, the concept of line is so primary that we use it subconsciously in our efforts to understand a design.

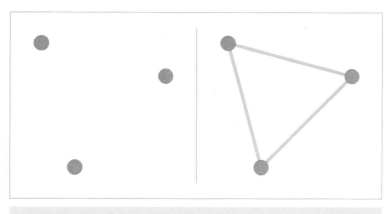

FIGURE 3-7

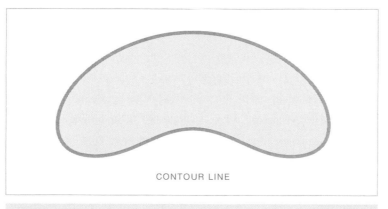

CONTOUR LINE

FIGURE 3-8

Just as lines have numerous visual qualities, they can also have a number of different functions in a design. They can serve as contours, imply movement or direction, organize a design's elements, or create shading and texture.

One of line's most essential functions is to generate boundaries or delineate edges of forms. A line that circumscribes the outermost limits of a shape is known as a **contour line** (3-8). Contour lines serve to separate

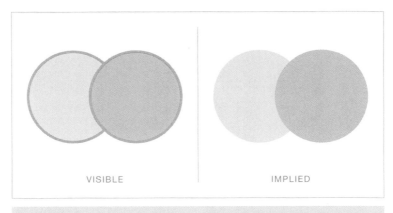

VISIBLE IMPLIED

FIGURE 3-9

one visual area from another, giving definition and shape to those areas. Contour lines are visible when they are given a particular width and become a distinct element of the design. Lines of this nature are often referred to as **outlines**. Contour lines are implied when the edge of one form provides visual distinction with the background or the edge of another form. In this case, a line is suggested at the boundary between the two contrasting areas but is not actually present (3-9). In either situation, contour lines serve to communicate shape and form in a design.

Another function of line is to establish movement and direction in a design. Because a line can be thought of as a point moving through space, it provides a record of motion. A viewer's eye will naturally follow this linear progression in a design. Because of this, line is perhaps the most effective device for leading the eye along a path (3-10). The direction or orientation a line takes also has a great effect on how it is perceived. Because the traditional format for most designs is a rectangle, any horizontal or vertical lines in a design are parallel to the edges of the frame and perceived as more inherently stable. Because of our experience of gravity, horizontal

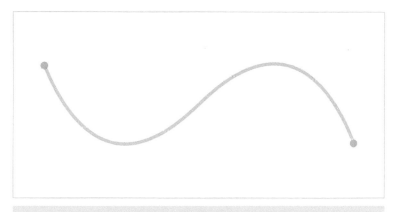

FIGURE 3-10

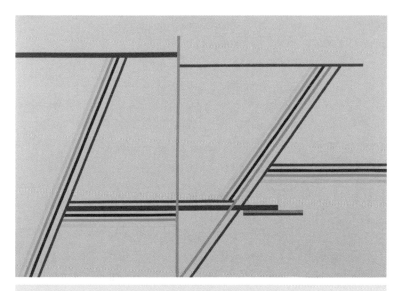

LINE ORIENTATION. Ann Pibal, **MNGO,** 2010. Acrylic on aluminum panel, 12.5 x 17.75 inches (31.75 x 41.1 cm). © *Ann Pibal. Courtesy Meulensteen Gallery, New York. Private Collection, Boston.*

lines tend to denote rest and inactivity, and vertical lines, while still visibly stable, tend to be more assertive and suggest a greater possibility of action. Diagonal lines are even more dynamic because they break from

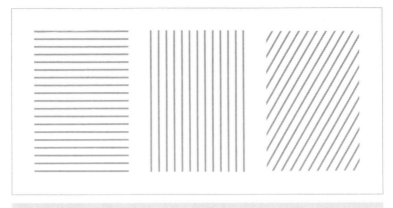

FIGURE 3-11

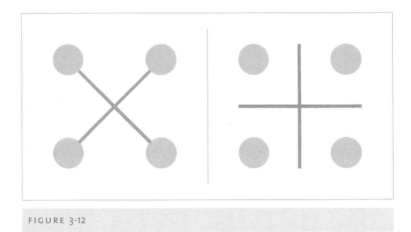

FIGURE 3-12

the direction of the rectangular frame and imply additional movement or activity (3-11).

Line can also be utilized in design as a tool for organization. Lines can connect related elements and divide unrelated ones; they can contain or they can separate (3-12).

Furthermore, lines can be used to create effects of shading and texture. By placing a series of lines close to one another, a designer can generate the

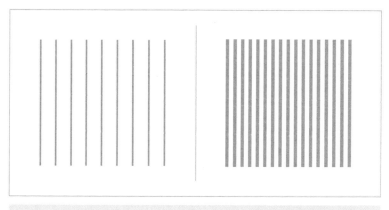

FIGURE 3-13

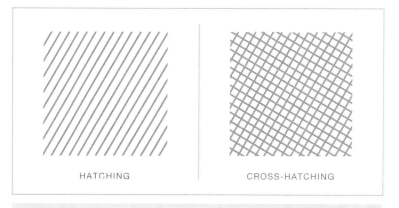

HATCHING | CROSS-HATCHING

FIGURE 3-14

impression of a textured gray area. And by varying the thickness and spacing between those lines, the designer can control the lightness or darkness of the shading. Thin lines or lines that are farther apart will produce lighter values, while thick lines or lines that are closer together will produce darker values (3-13). When repeated lines parallel one another, the effect is commonly known as **hatching**. When repeated lines intersect one another, the effect is commonly known as **cross-hatching** (3-14). In addition to suggesting shading, both techniques can also create a wide variety of textural effects.

SHAPE

O4 SHAPE

In addition to point and line, the other primary visual element that can be identified in two-dimensional design is shape. Through shape we are able to discern and identify the visual forms that comprise our world. All visible objects have shape, and we are able to comprehend the nature of an object by the quality of its shape.

A **shape** can be defined as a distinct area that is visually separated from the picture plane and the other elements of the design. It is a closed two-dimensional figure described either by an enclosing line or by contrast differences along its edges. A shape is an identifiable visual unit with a discrete length and width (4-1). Often the word **form** is substituted for the word shape.

All shapes have boundaries or edges that define their outer limits. These edges are usually active places in the design, where changes occur and where comparisons are made. Lines inherently describe the boundaries of a shape. A visible boundary is created when an actual

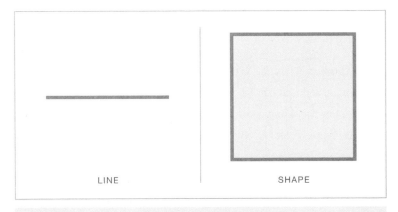

LINE | SHAPE

FIGURE 4-1

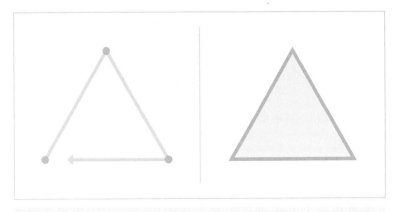

FIGURE 4-2

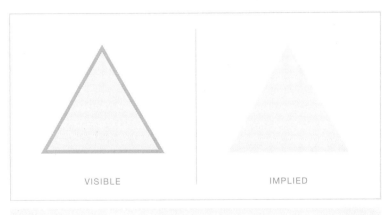

VISIBLE IMPLIED

FIGURE 4-3

line of some thickness is used to delineate the edges of a shape. In this sense, a shape can be thought of as the space that is described when a line traces a path back to its point of origin (4-2). The boundary line forms a closed loop that defines the inner area of the shape. Boundary lines, however, can also be implied or conceptual (4-3). This is the case when a visible line is not present along the edge of a shape. Instead, the line defining the boundary of the shape is implied through a visual difference between the shape itself and the area

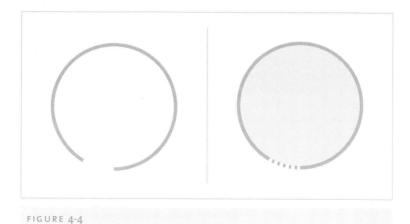

FIGURE 4-4

immediately surrounding it. This visual contrast creates an implied line that acts as the outer contour of the shape.

Even if a contour line is incomplete and does not form a closed path, it can still convey a sense of shape. We seek completeness in shape and often mentally resolve missing information. For example, a circle with a gap in its boundary would still be perceived as a circle as we mentally fill in the missing information to create a familiar shape (4-4). This phenomenon is commonly referred to as **closure**.

Just as line is capable of endless variety, shapes can also have a vast range of visual qualities. Shapes can be square or round, wide or tall, smooth or jagged, simple or complex. But it is often customary to categorize shapes into two broad classes: geometric and organic. **Geometric shapes** are mechanical or mathematical in character and are normally perceived as being relatively static or stable (4-5). They tend to be simpler in construction than organic shapes, and they may also be symmetrical, with one half of the shape being the mirror image of the other half. This category

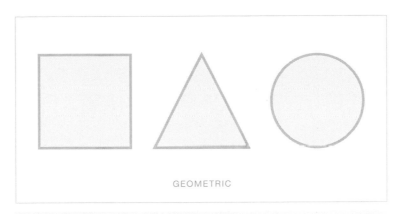

GEOMETRIC

FIGURE 4-5

GEOMETRIC SHAPE. Sarah Morris, Owl [Clips], 2009. Household gloss paint on canvas, 84.25 x 84.25 inches. (214 x 214 cm). © *Parallax. Courtesy Friedrich Petzel Gallery, New York.*

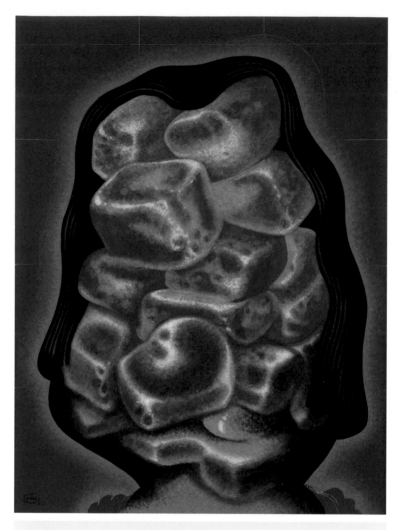

ORGANIC SHAPE. Peter Saul, **Cold Woman**, 2002. Synthetic polymer paint and colored pencil on board, 40 1/4 x 30 inches (102.2 x 76.2 cm). © *Peter Saul. The Judith Rothschild Foundation Contemporary Drawings Collection Gift. The Museum of Modern Art, New York, NY, USA. Digital Image © The Museum of Modern Art/Licensed by SCALA/Art Resource, NY.*

ORGANIC

FIGURE 4-6

includes the basic shapes that are generally studied in geometry: the square, the rectangle, the triangle, the circle, and so on. **Organic shapes**, on the other hand, are generally derived from forms found in nature. They tend to be rounded, irregular, and free-flowing (4-6). They also tend to be more visually complex than geometric shapes. These characteristics often suggest movement or growth and give organic shapes a more dynamic quality.

SIZE

05

O5 **SIZE**

Having introduced the primary visual elements that comprise a design, we must now investigate the various qualities these elements can possess. The first quality we will consider is size. All visual forms have a defined size; they occupy a certain area of space within a design (5-1). **Size** is defined as the physical dimensions or the magnitude of an object and is a measurable attribute. The term **scale** is often used interchangeably with size.

Size is also a relative quality. A design element is only big or small in comparison to other design elements or to the overall format of the design. A form may appear small if placed next to a larger form, or it may appear large if placed next to a smaller form (5-2). Similarly, a form may appear small if placed in a large format, or it may appear large if placed in a small format (5-3). So while size is something we are able to measure numerically, the apparent size of an object can change given the context in which it is placed.

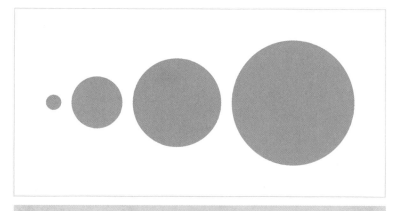

FIGURE 5-1

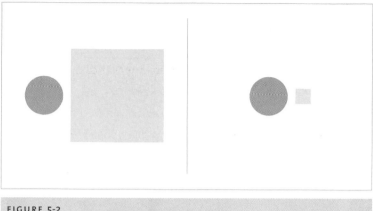

FIGURE 5-2

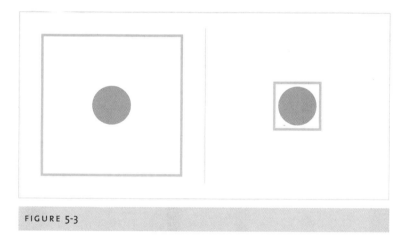

FIGURE 5-3

Another concept closely related to size is proportion. **Proportion** refers to the size relationships between the various elements of a design (5-4). The idea of proportion is closely linked to the idea of ratio, where we judge proportion by considering the ratio, in size, between individual units. Designers are continually confronted with choices about proportion. How big should one element be in relationship to another, and how big should each element be in relationship to the overall design?

VARIATION IN SIZE. David Moreno, Untitled, 2001. Ink, colored ink, and pencil on graph paper, 12 7/8 x 9 1/2 inches (32.7 x 24.1 cm). © David Moreno. Courtesy Feature Inc., New York. The Museum of Modern Art, New York. Judith Rothschild Foundation Contemporary Drawings Collection Gift.

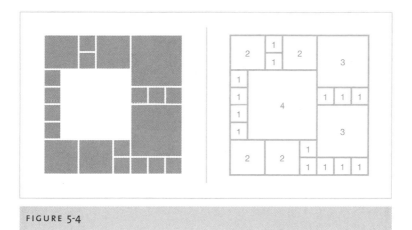

FIGURE 5-4

These decisions will ultimately affect the way the elements of a design interact with one another and will have bearing on the overall balance and unity of the design. Such decisions can also determine whether a sense of depth is present in a design or if a sense of rhythm or movement is generated.

COLOR

06

o6 COLOR

Color is one of the most powerful and complex visual qualities. It defines shape, provides emphasis, and conveys emotion. When used properly, color establishes the overall tone or mood of a design. Every **color** in existence has three defining properties: hue, value, and saturation. It is the unique combination of these three properties that indentifies an individual color.

VARIATION IN HUE. Tim Bavington, Whats The Frequency Kenneth?, 2009. Synthetic polymer on canvas, 60 x 60 inches (152.4 x 152.4 cm). © *Tim Bavington. Courtesy of the artist and Jack Shainman Gallery, New York.*

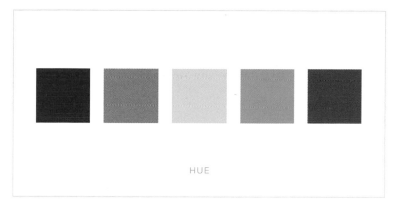

FIGURE 6-1

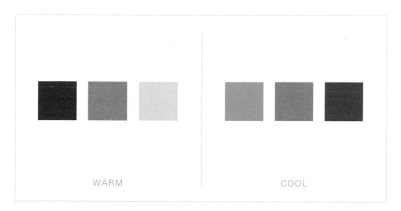

FIGURE 6-2

When describing a color as red, green, or blue, we are referring to the hue of that color (6-1). The name we assign to a color in its purest form is a description of that color's **hue**. In addition to these standard hue names, the sensation of temperature can also be used to describe hue. Warm hues, such as red, orange, and yellow, are associated with sunlight or fire. Warm hues generally express an active or assertive quality. Cool hues, such as green and blue, are associated with plants, ice, and water. Cool hues are normally considered to be quiet and relaxing (6-2).

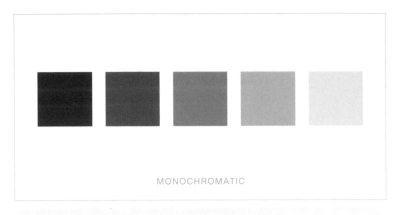

MONOCHROMATIC

FIGURE 6-3

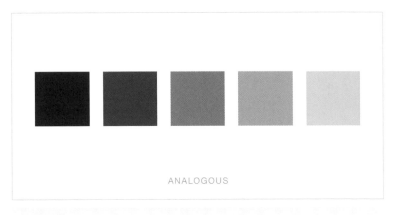

ANALOGOUS

FIGURE 6-4

When multiple colors are utilized in a design, the relationship between the hues of those colors should be considered. A group of colors that is restricted to a single hue is defined as being **monochromatic** (6-3). Monochromatic colors are fixed in hue and only have variation in value or saturation. A group of colors that utilizes multiple but similar hues is considered **analogous** (6-4). Analogous colors possess an overriding

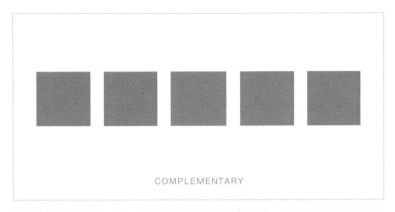

COMPLEMENTARY

FIGURE 6-5

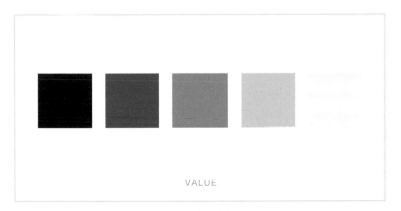

VALUE

FIGURE 6-6

hue bias or commonality in hue. Additionally, two colors that exhibit the maximum difference in hue are considered to be **complementary** (6-5). Complementary colors have a strong visual interaction and intensify one another in strength.

In addition to hue, all colors also possess the defining property of value. **Value** is defined as the relative lightness or darkness of a color (6-6).

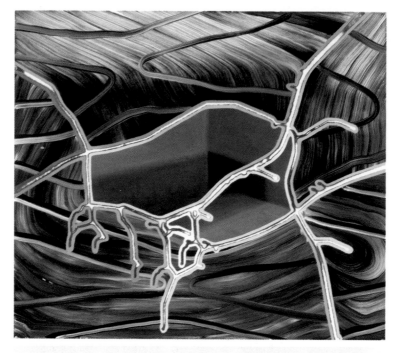

VARIATION IN VALUE. Bill Komoski, 1/7/09, 2009. Acrylic paint on canvas; 26 x 30 inches (66 x 76 cm). © *Bill Komoski. Photography by Jason Mandella. Courtesy Feature Inc., New York.*

The value of a color can be measured through the use of a value or tonal scale. A value scale ranges from white—the lightest value, to black—the darkest value. Intermediate values between the extremes of white and black are indicated by an even gradation of grays (6-7). Colors can then be compared against this scale to determine their value. For example, pure yellow is light in value, while navy blue is dark in value. Perhaps the easiest way to conceptualize this comparison is to imagine taking a

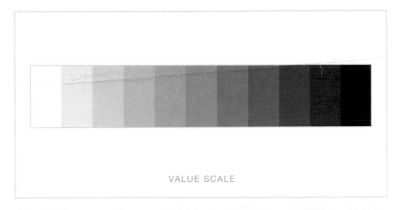

VALUE SCALE

FIGURE 6-7

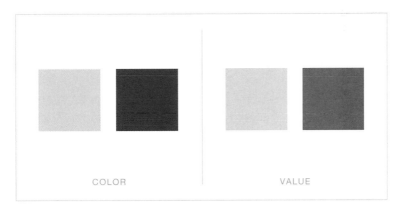

COLOR VALUE

FIGURE 6-8

black and white photograph of a color. The resulting gray would indicate the value level of that color (6-8).

Given a single hue, there are three types of value variations that can be generated: tints, shades, and tones. Adding white to a hue creates a

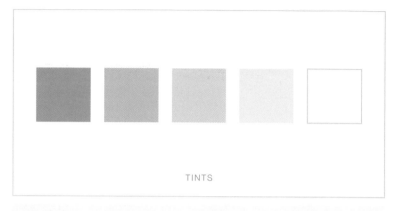

TINTS

FIGURE 6-9

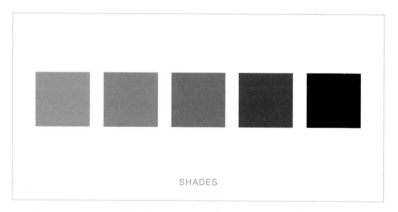

SHADES

FIGURE 6-10

tint of that hue (6-9). Tints are always lighter in value than the original hue. Adding black to a hue creates a **shade** of that hue (6-10). Shades are always darker in value than the original hue. Finally, adding gray to a hue creates a **tone** of that hue (6-11). Depending on the value of the gray being added, tones may be lighter or darker than the original hue or may even maintain the same value.

As a design is constructed with differing values, an overall tonal key and tonal range are developed. The **tonal key** of a design is its overall

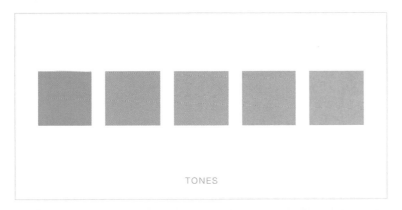

TONES

FIGURE 6-11

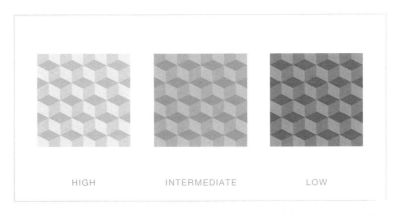

HIGH INTERMEDIATE LOW

FIGURE 6-12

tendency towards light, medium, or dark values. A design in which light values dominate is said to be **high-key** and usually reads as being lightweight or airy. A design in which mid-range values dominate is considered **intermediate-key** and normally reads as being stable or static. A design in which dark values dominate is said to be **low-key** and usually portrays a heavy or somber feeling (6-12). On the other hand, the **tonal range** of a design describes the amount of variety between the values of its colors. A design that utilizes a small range of values is said to have a narrow tonal range. A narrow tonal range only utilizes a small

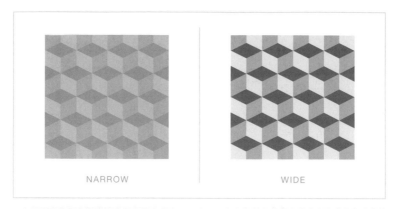

NARROW WIDE

FIGURE 6-13

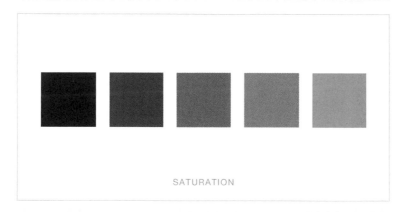

SATURATION

FIGURE 6-14

section of the value scale and typically generates a more relaxed and quiet impression. A design that utilizes a greater range of values is said to have a wide tonal range. A wide tonal range utilizes a considerably larger section of the value scale and normally yields a more energetic and active design (6-13).

The final defining property of color is saturation. Also known as **intensity** or **chroma**, **saturation** refers to the relative purity or strength of a color (6-14). Colors that have a high saturation are described as bright,

VARIATION IN SATURATION. Lecia Dole-Recio, Untitled (orng.ppr.slvr.crd), 2008. Acrylic, tape, cardboard, paper, 24.75 x 20.5 inches (62.8 x 52 cm). © Lecia Dole-Recio. Photography by Fredrik Nilsen. Courtesy Richard Telles Fine Art, Los Angeles.

vivid, pure, strong, or brilliant. Colors that have a low saturation are described as pale, dull, muted, or weak. As a color decreases in saturation, it progressively takes on the appearance of being gray.

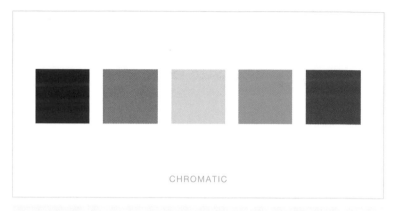

CHROMATIC

FIGURE 6-15

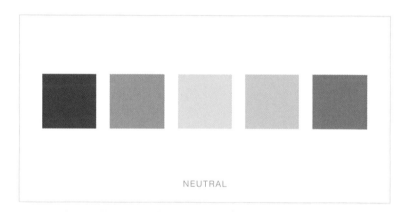

NEUTRAL

FIGURE 6-16

Chromatic colors are defined as colors that have some noticeable degree of saturation, allowing their hue quality to be perceptible (6-15). Most colors fall into this category. **Neutral** colors are generally defined as colors with minimal saturation, making their hue quality less distinguishable overall (6-16). Warm grays, cool grays, and assorted browns are all considered to be neutral. **Achromatic** colors are colors with no saturation and no discernible hue quality (6-17). Black, white, and fully desaturated grays are considered achromatic.

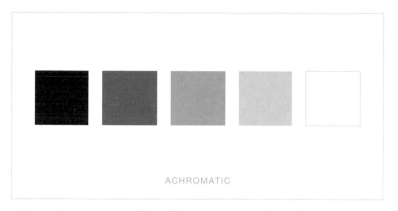

ACHROMATIC

FIGURE 6-17

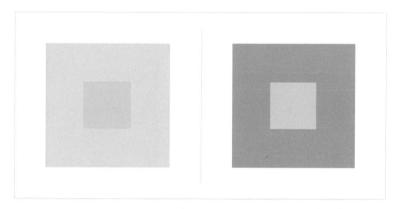

FIGURE 6-18

Like size, color is also a relative quality. As colors interact within a design, they influence the appearance of one another. Specifically, the similarities of neighboring colors will be reduced and their differences will be amplified. This phenomenon is known as **simultaneous contrast** and can cause apparent changes in the hue, value, or saturation of a color. In terms of hue, a color will diminish the appearance of its own hue within a neighboring color (6-18). At the same time, a color will also

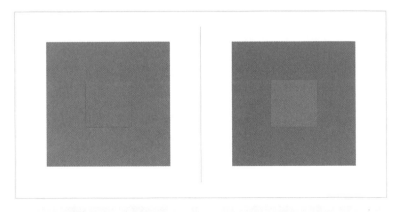

FIGURE 6-19

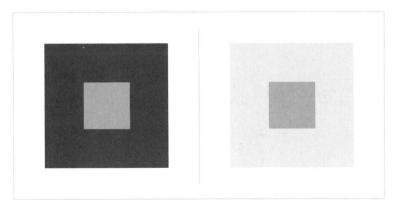

FIGURE 6-20

emphasize its complementary hue within a neighboring color (6-19). Simultaneous contrast also affects the properties of value and satura- tion. The value of a color will appear lighter when compared to a darker color and darker when compared to a lighter color (6-20). Similarly, the

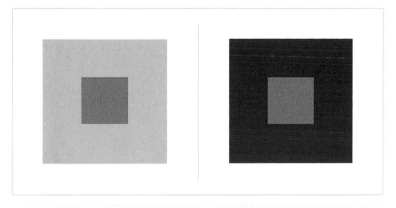

FIGURE 6-21

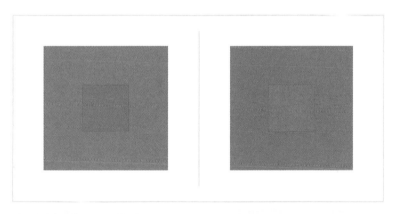

FIGURE 6-22

saturation of a color will appear stronger when compared to a weaker color and weaker when compared to a stronger color (6-21). Also, when comparing two adjacent colors with complementary hues, each will appear to intensify the saturation of the other (6-22).

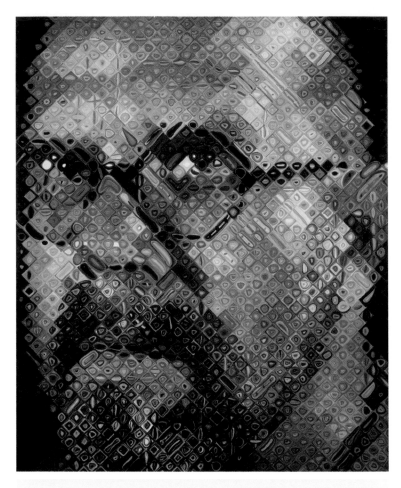

OPTICAL MIXING. Chuck Close, **Self-Portrait**, 1997. Oil on canvas, 8' 6" x 7' (259.1 x 213.4 cm). © *Chuck Close, courtesy The Pace Gallery. Photography by Ellen Page Wilson, courtesy The Pace Gallery. The Museum of Modern Art, New York. Gift of Agnes Gund, Jo Carole and Ronald S. Lauder, Donald L. Bryant, Jr., Leon Black, Michael and Judy Ovitz, Anna Marie and Robert F. Shapiro, Leila and Melville Straus, Doris and Donald Fisher, and purchase.*

FIGURE 6-23

A somewhat opposite effect to simultaneous contrast is optical mixing. **Optical mixing** occurs when small areas of color are placed close together and visually mix to form a new color (6-23). In optical mixing, neighboring colors blend to create a perceived average, rather than intensifying each other's differences. This effect relies heavily on the colored elements being sufficiently small in size.

TEXTURE

07

07 TEXTURE

In addition to size and color, every element in a design also has the quality of texture. In general, **texture** is defined as the physical surface quality of an object. However, in two-dimensional design, textures are inherently flat and purely visual in nature. While the use of texture lends visual interest to a design, it can also appeal to our sense of touch and help to more fully describe our visual experience.

Two-dimensional textures, while physically flat, may still generate the visual impression of a three-dimensional surface. This type of texture is known as **implied texture** (7-1). Implied textures have no actual surface characteristics, but still evoke tactile sensations from the viewer. We remember what objects feel like when we touch them, and implied textures recall those perceptions. Implied textures can appear smooth and polished, or bumpy and rough. They can be fine or coarse, uniform or irregular (7-2). The perception of implied texture is closely tied to the way light falls on physically textured surfaces, creating variations in value.

IMPLIED

FIGURE 7-1

FIGURE 7-2

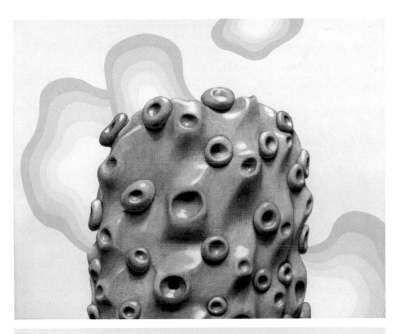

IMPLIED TEXTURE. Alexander Ross, Untitled, 2009. Ink, graphite, colored pencil, watercolor and flashe on paper, 22 5/8 x 28 1/8 inches (57.5 x 71.4 cm). © Alexander Ross. Courtesy David Nolan Gallery, New York.

The patterns of light and dark that are created by an actual texture, and suggested by an implied texture, trigger the visual recollection of a tactile sensation.

Another kind of texture that can be utilized in two-dimensional design is visual texture. Unlike implied texture, **visual texture** does not appeal to our sense of touch or evoke a tactile response (7-3). Visual textures are generated in the same way as implied textures, by utilizing variations in color and value, but the result does not resemble a physical surface. Instead, visual textures appeal solely to our sense of sight and provide visual variety and interest. One broad category of visual texture is pattern. **Pattern** refers to the systematic recurrence of a motif, which is repeated and organized over a portion of a design (7-4). These repeated elements are psychologically grouped together by the viewer, creating the impression of a larger, unified area with a particular visual texture.

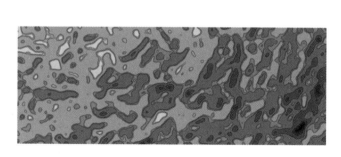

VISUAL

FIGURE 7-3

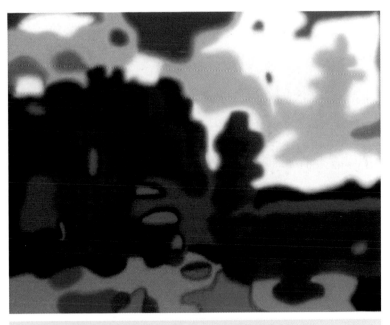

VISUAL TEXTURE. Robert Koons, **Constable . . . Another Fake,** 2001. Oil on canvas, 24 x 30 inches (61 x 76.2 cm). © *Robert Koons. Courtesy of the artist.*

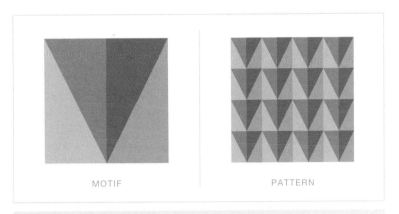

MOTIF

PATTERN

FIGURE 7-4

PATTERN. Gary Andrew Clarke, **Window Lights,** 2011. Giclee print, 11.7 x 16.5 inches (297 mm x 430 mm). © *Gary Andrew Clarke. Courtesy of the artist, Graphic Nothing www.graphicnothing.com*

COMPOSITION

08

O8 COMPOSITION

Having examined the elements of design and their visual qualities, we can now consider how these elements are assembled to form a design. The end product of the design process is a **composition**, which is the arrangement of the individual pieces that comprise the design. A composition is the result of all the visual elements, each with its individual characteristics, interacting with one another inside the format of the design. It is how the parts of the design are combined to form a unified whole.

The manner in which a composition is constructed and organized is often called the structure of the composition. The **structure** of a composition provides the underlying framework that governs the arrangement and positioning of its forms (8-1). It determines the internal relationships between the elements of the composition and gives them a visual logic or order. Structures can be rigid or loose, and they can be readily apparent to the viewer or simply implied (8-2).

FIGURE 8-1

FIGURE 8-2

FIGURE 8-3

A new composition begins with an empty format that is ready to receive the elements of the design. As forms are placed in a composition, the picture plane is broken up into occupied regions and empty regions. When an area of a composition appears occupied, that area is viewed as a **positive shape** (8-3). As elements are placed in an empty composition, they immediately appear to fill space and therefore become positive. Positive shapes stand forward in a composition, and as a whole, are commonly known as **figure** or **foreground**. On the other hand, when an area of a

composition appears empty or unoccupied, that area is considered to be negative (8-4). **Negative areas** are the leftover spaces that surround the positive shapes. Negative areas appear to recede in a composition, and as a whole, are commonly known as **ground** or **background**.

While the positive shapes of a composition are usually viewed as the active portions of a design, thoughtful consideration should also be given to the negative areas. Even though negative regions read as empty, they share the same edges as the positive shapes they encompass (8-5).

FIGURE 8-4

FIGURE 8-5

The negative areas of a design surround the positive shapes, but the positive shapes, in turn, also surround the negative areas. The foreground and background of a composition are therefore interconnected and dependent on one another. By understanding and controlling this interaction, often referred to as the **figure-ground** relationship, a designer is able to build a balanced composition and a unified design.

Sometimes, when the positive areas of a design carve out identifiable shapes in the negative areas, the distinction between figure and ground becomes less obvious. The positive and negative shapes of a composition can become so intertwined that it becomes impossible to distinguish one from the other. This is known as **reversible figure-ground**, and usually occurs when the amounts of positive and negative space are roughly equal (8-6). Reversible figure-ground can cause visual confusion because the relationship between figure and ground alternates. Certain areas may initially read as being positive, but with a visual or mental adjustment, those areas are suddenly pushed into the background, making the negative areas come forward. This effect may be unwanted

FIGURE 8-6

REVERSIBLE FIGURE-GROUND. Aaron Wexler, **Prisoner of Imagination**, 2007. Acrylic and paper on panel 48 x 72 inches (122 x 183 cm). © *Aaron Wexler, 2007. Courtesy Saatchi Gallery, London.*

or it may be desirable, depending on the intention of the design. When utilized, reversible figure-ground should always be applied with purpose and intent.

SPACE

09

09 SPACE

Although the picture plane of a two-dimensional design is inherently a flat surface, it is still possible for a designer to create the illusion of a third dimension. Compositional elements can appear to reside in a space behind the picture plane at a particular **depth**. We live in a world of three dimensions, where objects with three-dimensional volume exist in three-dimensional space. In many cases, a designer will want to recreate this sense of depth or volume and there are many techniques for generating this impression. But when an illusion of depth or volume is created in a two-dimensional composition, it is precisely that, an illusion of **space**.

ILLUSION OF DEPTH. Dirk Skreber, Art Arfons Facing Unforeseen Problems 2.0, 2007. Oil and foil tape on canvas, 47.24 x 70.87 inches (120 x 180 cm). © Dirk Skreber. Courtesy Friedrich Petzel Gallery, New York.

When a sense of **space** is implied in a composition, different magnitudes of **depth** can be achieved. The space of a design can be flat, where all forms appear to lie on the picture plane itself (9-1). In this type of space, the design elements seem to be the same distance from the viewer, with no forms having the illusion of receding into the composition. The space of a design can be shallow, where forms begin to take on an illusion of depth but in a limited space behind the picture plane (9-2). In this type of space, design elements appear to reside at slightly different distances from the viewer, but the sense of depth is finite with forms staying close to the

FIGURE 9-1

FIGURE 9-2

FIGURE 9-3

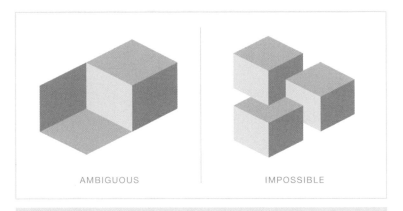

AMBIGUOUS IMPOSSIBLE

FIGURE 9-4

front surface of the picture plane. The space of a design can also be deep, where forms possess a strong illusion of depth in a seemingly endless space behind the picture plane (9-3). In this type of space, design elements appear to reside in a wide range of varying distances from the viewer.

In addition to appearing flat, shallow, or deep, the implied space of a two-dimensional design can also be ambiguous or it can be physically impossible (9-4). The space of a design becomes ambiguous when it alternates between two different spatial illusions. At one moment an area of the design appears to advance, but at another moment it

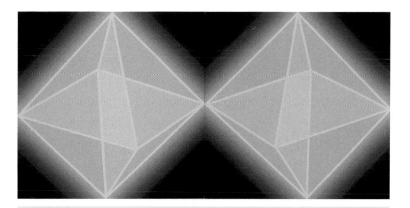

AMBIGUOUS SPACE. David Malek, **Mirrored Octahedron**, 2008. Diptych, enamel on wood, each panel 30 x 30 inches (76.2 x 76.2 cm). © *David Malek. Courtesy of the artist.*

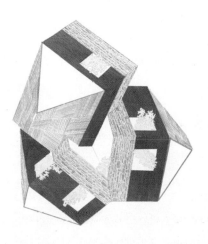

IMPOSSIBLE SPACE. Kevin Appel, **Untitled**, 2003. Cut-and-pasted printed paper, cut-and-pasted paper, wood veneer, and pencil on paper, 17 x 14 inches (43.2 x 35.6 cm). © *Kevin Appel. Courtesy the artist. The Museum of Modern Art, New York. Judith Rothschild Foundation, Contemporary Drawings Collection Gift.*

appears to recede. This yields a situation where the viewer is unable to specifically determine the spatial orientation of the design. The space of a design is considered impossible when it creates a spatial illusion that is in contradiction with our visual experience of the natural world. In this case, the apparent space is absurd and cannot exist in reality. This creates a sense of confusion for the viewer, because the presentation of space is physically unachievable. A spatial illusion that is ambiguous or impossible may be an unwanted effect or a desired result depending on the goals of the designer. As with all design decisions, the use of ambiguous or impossible space should always be purposeful and intentional.

There are many techniques for generating the illusion of space in a design. Elements that overlap, change size, or change direction can produce an impression of depth. The use of color can also affect the apparent spatial location of forms in a composition, and the techniques of aerial and linear perspective can be applied to further enhance an illusion of depth.

Perhaps the simplest way to create an illusion of depth is through overlapping. When one form overlaps and partially covers another form, it appears spatially to be in front of the other form (9-5). This provides a

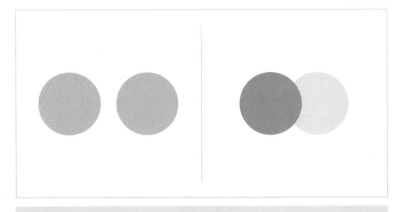

FIGURE 9-5

FIGURE 9-6

basic illusion of depth, although the effect is usually limited without the utilization of additional techniques.

Another method for generating the illusion of space in a design is the manipulation of size. As an object moves away from us in space, it appears to get visually smaller in size (9-6). This fact allows a designer to use diminishing size to indicate the spatial location of a compositional element. Larger forms appear closer to the viewer, while smaller forms appear farther away.

The apparent direction a form has in a composition can also influence the illusion of depth. If a compositional element appears to be rotated in space, breaking the flat surface of the picture plane, it will suggest the existence of a space behind the picture plane. This effect also occurs if forms appear to be bent or curved away from the picture plane (9-7).

Additionally, the use of color can significantly influence the sense of depth in a design. The apparent spatial location of a color is determined by its defining properties of hue, value, and saturation. Colors that are warm in hue tend to advance, while colors that are cool

FIGURE 9-7

FIGURE 9-8

in hue tend to recede (9-8). Areas of high value contrast appear to come forward in space, while areas of low value contrast appear to move back in space (9-9). Furthermore, colors that are high in saturation tend to advance, while colors that are low in saturation tend to recede (9-10).

Another method for enhancing the apparent depth of an element in a composition is **aerial** or **atmospheric perspective**. This technique

FIGURE 9-9

FIGURE 9-10

relies on the fact that distant objects are seen through a layer of air or atmosphere, making them appear softer and more diffuse to the viewer. This visual phenomenon allows a designer to use the apparent clarity of a form in a composition to suggest its spatial location. Forms that are blurry and less distinct appear farther away, while more detailed forms in sharper focus are viewed as being closer (9-11). The effect of aerial perspective can be further developed through the use of color. Giving foreground elements a high degree of contrast and assigning cooler and

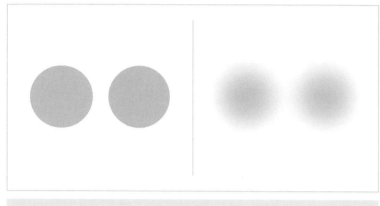

FIGURE 9-11

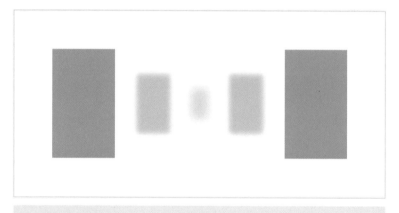

FIGURE 9-12

paler colors to elements in the distance will additionally increase the sense of space (9-12).

The most scientific and rigorous technique for generating the illusion of space is linear perspective. Developed in the 15th century by Italian artists and draftsmen, **linear perspective** is a mechanical system for representing three-dimensional objects on a two-dimensional surface. Linear perspective is based on two basic tenets. First, as objects become more distant, they appear to get smaller in size. Second, as parallel lines recede

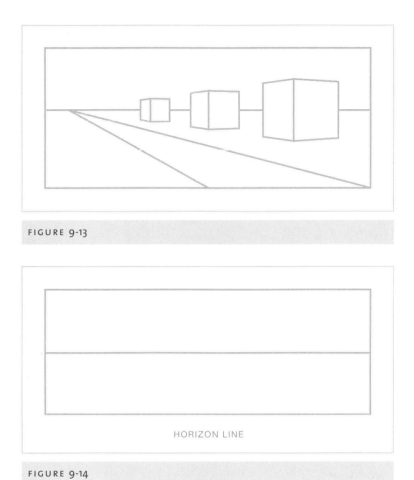

FIGURE 9-13

FIGURE 9-14

in space, they appear to converge at a point (9-13). These two simple observations form the basis on which the methods of linear perspective have been developed.

The first guide used in linear perspective is the **horizon line** (9-14). It is a horizontal line that runs across the picture plane and corresponds to the eye level of the viewer. This line is meant to represent the visual boundary where the earth meets the sky. Once the horizon line is established, a number of points are located in the composition that govern the convergence

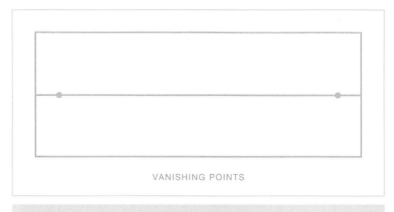

VANISHING POINTS

FIGURE 9-15

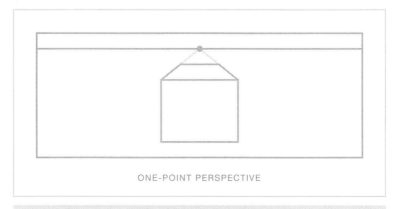

ONE-POINT PERSPECTIVE

FIGURE 9-16

of receding lines in the image. These points are known as **vanishing points**, and they are the locations where receding parallel lines meet (9-15). The number of vanishing points in a composition defines the type of perspective being used. The most common types of linear perspective are one-point perspective, two-point perspective, and three-point perspective.

As the name suggests, one-point perspective utilizes one vanishing point. It is used when viewing the front face of an object, where the height and width of the object are parallel to the picture plane (9-16). In one-point perspective, one side of the object is facing the viewer, while

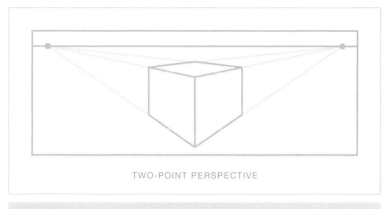

TWO-POINT PERSPECTIVE

FIGURE 9-17

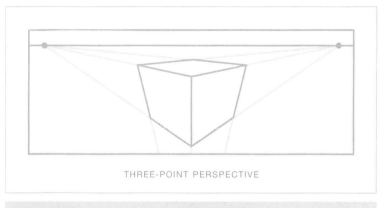

THREE-POINT PERSPECTIVE

FIGURE 9-18

its remaining visible sides trail off towards a single vanishing point on the horizon line. Two-point perspective, on the other hand, utilizes two vanishing points. It is used when viewing an object from an angle, where only the height of the object is parallel to the picture plane (9-17). In two-point perspective, one edge of the object is facing the viewer, and its sides trail off towards two vanishing points located on either side of the horizon line. Similarly, three-point perspective utilizes three vanishing points. It is used when viewing an object from above or below, where none of the object's edges are parallel to the picture plane (9-18).

In three-point perspective, a corner of the object is facing the viewer, and all of its sides trail off towards one of three vanishing points. Two of these vanishing points are located on either side of the horizon line, and the third is located above or below the horizon line, depending on the viewing angle.

Once a composition has an illusion of depth and space, an important outcome is that the forms of the design have an opportunity to take on the illusion of volume. When an illusion of three-dimensional space is generated behind the picture plane, it is also possible to create forms with the appearance of mass or **volume** to fill that space. The techniques of linear perspective can be used to give forms the illusion of volume by allowing the viewer to see multiple sides of the same object. But the most common method for creating a sense of volume is shading. When light strikes a three-dimensional object, areas of highlight and shadow are generated. This effect can be emulated in a two-dimensional design through the manipulation of value (9-19). Lighter values suggest highlights, while darker values suggest shadows. By utilizing a range

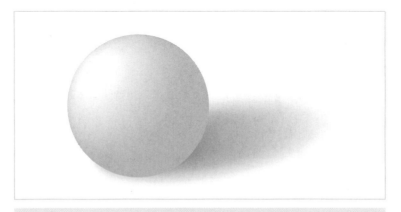

FIGURE 9-19

of values in a composition, a designer can replicate the impression of light falling on an object and thereby generate the illusion of three-dimensional volume.

ILLUSION OF VOLUME. Pierre Dorion, **Copier**, 2007. Watercolour and gouache on paper, 12 x 9 inches (30.5 x 22.9 cm). © *Pierre Dorion. Courtesy of the artist and Jack Shainman Gallery, New York.*

GROUPING

10

10 GROUPING

As multiple elements are placed in a design, a series of visual interactions will begin to occur between those elements. These interactions can connect related elements to form groups within a composition. While a designer can establish groups through the physical placement of forms in a composition, grouping can also be the psychological result of a viewer trying to organize and understand a composition.

When two or more forms come in contact in a design, they become attached to one another and create a group. There are numerous ways

PHYSICAL GROUPING. Ginny Bishton, De nada (purple and red), 2009. Photo collage on paper, 28 x 28 inches (71 x 71 cm). © Ginny Bishton. Photography by Fredrik Nilsen. Courtesy Richard Telles Fine Art, Los Angeles.

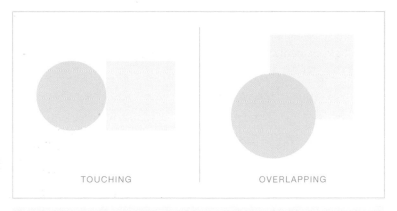

TOUCHING OVERLAPPING

FIGURE 10-1

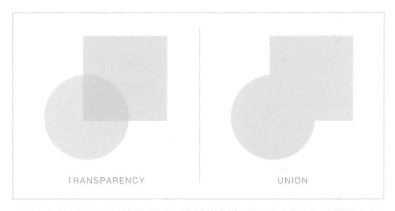

TRANSPARENCY UNION

FIGURE 10-2

forms can interact with one another to create physical groups. Forms can simply touch at a point or a line and share edges where they meet. Forms can also **overlap**, where one form partially passes over another and appears to be residing on top of it (10-1). Overlapping can also occur with an illusion of **transparency**, where the viewer is able to see through the overriding form to some degree, making the form beneath partially visible. The **union** of overlapping forms creates a single, larger form by merging individual forms together (10-2). The **subtraction** of overlapping

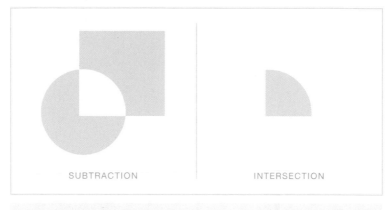

SUBTRACTION INTERSECTION

FIGURE 10-3

forms also yields a merged form, but the area common to the forms is removed, leaving a hole. The **intersection** of overlapping forms simply leaves behind the area that was common to the forms (10-3).

But even when forms do not come in physical contact with one another, they may still be visually grouped together by the viewer. We tend to simplify and organize what we see in an attempt to make sense of it. We try to find order in our visual experience, and when there is none, we will create it ourselves. This phenomenon is described by a number of grouping principles, also known as **Gestalt principles**, which help explain how visual input is organized into perceptual groups. Common grouping principles include proximity, similarity, continuity, common fate, good figure, and familiarity.

The principle of **proximity** states that elements are visually grouped together when they are positioned near one another. A viewer will perceive elements in a composition as belonging together when they are close to one another. A circle and a square, although dissimilar in shape, will be grouped together if they are placed in close proximity (10-4).

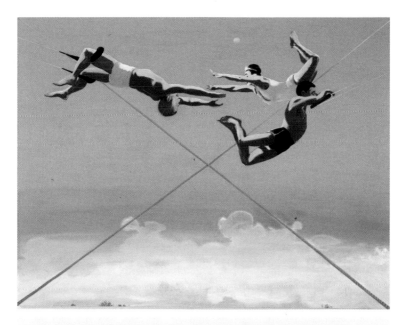

VISUAL GROUPING. Verne Dawson, **Three Aerialists,** 2004. Oil on canvas, 96 x 124 inches (243.8 x 315 cm). © *Verne Dawson. Courtesy Gavin Brown's Enterprise, New York.*

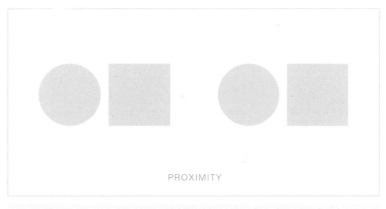

PROXIMITY

FIGURE 10-4

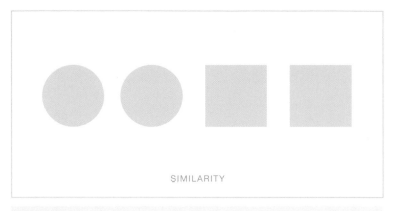

SIMILARITY

FIGURE 10-5

The principle of **similarity** states that objects with similar visual characteristics will be seen as belonging together. A viewer will perceptually group elements in a composition with analogous qualities, such as similarity in shape, size, color, or texture. Circles are grouped with other circles, squares with other squares, and so on (10-5).

The principle of **continuity** states that elements tend to be grouped when they are in alignment with one another. A viewer will perceptually group elements in a composition that follow a continuous path. A progression of shapes that have no visual relationship to one another will appear to be connected as long as they all lie on the same path. Even if that path is broken by another shape, the viewer will mentally continue the progression through the apparent barrier (10-6).

The principle of **common fate** states that elements moving in the same direction are seen as belonging together. Because the elements of a two-dimensional design cannot actually be in motion, a viewer will visually group elements that have the appearance of moving in the same direction or that have the same orientation. A set of lines pointing in the same direction in a composition will form a perceptual group (10-7).

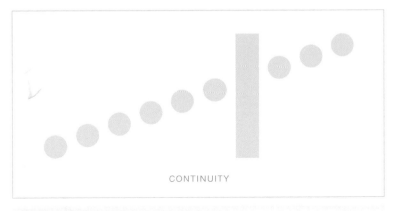

CONTINUITY

FIGURE 10-6

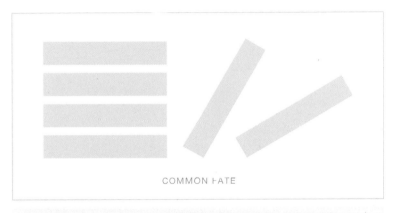

COMMON FATE

FIGURE 10-7

The principle of **good figure** states that elements tend to be grouped so the resulting image is as simple as possible. This means a viewer will try to group the elements of a composition into their most basic and orderly arrangement. A rectangle that is overlapping a series of circles reads as a set of basic overlapping shapes, rather than a more complex set of partially completed circles (10-8).

The principle of **familiarity** states that elements whose combination renders a meaningful or familiar image will appear as belonging together.

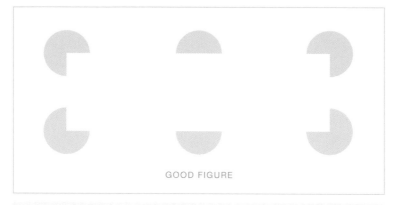

GOOD FIGURE

FIGURE 10-8

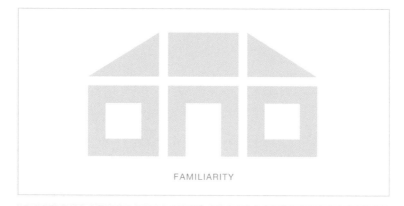

FAMILIARITY

FIGURE 10-9

This means a viewer will visually group a set of compositional elements if they form a recognizable image. A series of shapes that are arranged to resemble the form of a house will be seen as a group (10-9).

Understanding the principles of grouping helps a designer make compositional decisions concerning placement and organization. Knowing that a viewer will perceptually group and order the elements of a composition allows the designer to leave forms unconnected and relationships undefined. This forces the viewer to resolve any absent associations and take a more active role in examining and interpreting a design.

CONTRAST

11

11 CONTRAST

As elements are added to a composition, not only do they form groups with one another, but they also form contrasts. The act of making a form visible in a design is an exercise in contrast; it is an automatic part of the design process. We understand our world through visual contrast and without it we are unable to distinguish between different objects in our field of vision. Unless a design is simply a field of uniform color, it will utilize contrast in some manner.

Contrast in design is the use of dissimilar elements or properties to create visual distinctions. Every aspect of a composition is receptive to contrast. Contrast can occur in shape, size, color, texture, quantity, direction, position, and space. We generally think of contrast in terms of antonyms or opposites. Shapes can be geometric or organic, angular or rounded, regular or irregular. Sizes can be large or small, long or short, thick or thin (11-1). Colors can be warm or cool, light or dark, brilliant or dull, and textures can be smooth or rough, fine or coarse (11-2).

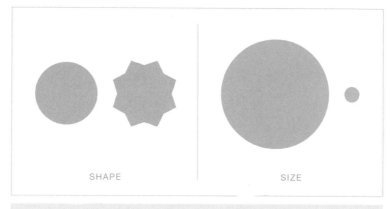

SHAPE SIZE

FIGURE 11-1

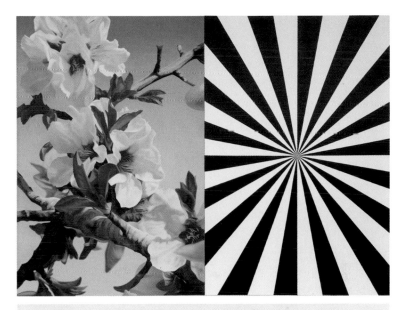

CONTRAST IN SHAPE. Mustafa Hulusi, **Exstacy Almond Blossom 3 (L)**, 2008. Oil on canvas (2 parts), 96 x 128 inches (244 x 325 cm). © *Mustafa Hulusi, 2011. Courtesy Max Wigram Gallery, London. Image courtesy Saatchi Gallery, London.*

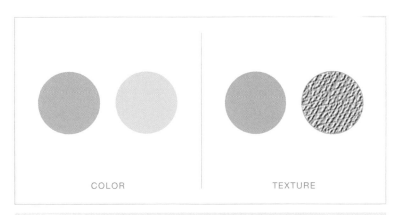

FIGURE 11-2

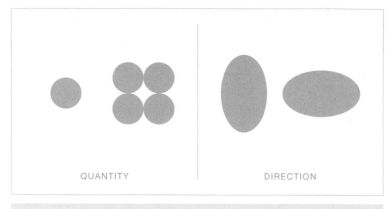

QUANTITY | DIRECTION

FIGURE 11-3

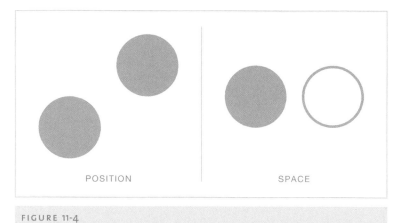

POSITION | SPACE

FIGURE 11-4

Quantities can be many or few, and directions can be straight or curved, horizontal or vertical (11-3). Positions can be high or low, left or right, centered or off-center, and space can be occupied or unoccupied, deep or shallow (11-4).

CONTRAST IN COLOR. Bob Knox, **Neutrabstract**, 2008. Acrylic on canvas, 66 x 92 inches (167.6 x 233.7 cm). © Box Knox. *Courtesy of the artist and Jack Shainman Gallery, New York.*

The use of contrast in design, however, goes far beyond the simple application of visual opposites. Contrast is a complex relationship dealing with multiple levels of comparison. Every element in a design has numerous visual qualities that can be adjusted, and every visual quality has various degrees of adjustment. Two elements in a design can be similar in certain visual aspects, but possess contrast in

CONTRAST IN TEXTURE. Luke Rudolf, **Portrait No. 19**, 2010. Acrylic and oil on canvas, 59 x 49.2 inches (150 x 125 cm). © *Luke Rudolf. Courtesy Kate MacGarry Gallery, London.*

others (11-5). Contrast may also differ in degree, from subtle variation to extreme difference (11-6). This variability provides endless opportunity for the kind and amount of contrast in a design.

FIGURE 11-5

FIGURE 11-6

By emphasizing visual differences, contrast adds variety and diversity to a composition. One of a designer's primary objectives is to determine the overall amount of contrast necessary for a design. Designs with low overall contrast are subtle and calm, while designs with high overall

FIGURE 11-7

FIGURE 11-8

contrast are bold and active (11-7). Designs with too little contrast lack visual interest, while designs with too much contrast lack unity (11-8). Because of this, contrast should always be applied in a purposeful and balanced way.

BALANCE

12

12 BALANCE

As elements collect or contrast with one another in a composition, an overall sense of balance or imbalance will result. Because we live in a world that is governed by the law of gravity, we tend to project the same sense of gravity onto the images we see. We mentally assign different visual weights to forms in a composition, and the arrangement of those forms determines whether the design is balanced. Designs that appear balanced tend to put the viewer at ease, while those that lack balance tend to create a sense of tension or conflict.

All forms within a composition appear to be under the influence of gravity and experience a visual pull towards the bottom of the design. To create balance, or to purposefully push a design out of balance, the apparent weight of each form must be considered. The qualities of shape, size, color, and texture will determine how heavy or light a form appears in a composition. Complex or irregular shapes possess greater visual weight than simple or regular shapes (12-1). Large sizes appear visually heavier than small sizes (12-2). Colors in high contrast appear visually heavier than those in low contrast (12-3). And detailed textures have greater visual weight than undefined textures (12-4).

FIGURE 12-1

FIGURE 12-2

FIGURE 12-3

FIGURE 12-4

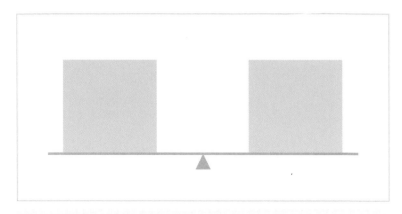

FIGURE 12-5

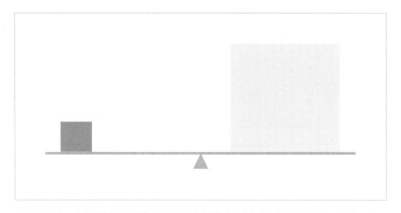

FIGURE 12-6

The overall **balance** of a design is determined by the distribution of visual weight within the composition. In the same way weights are placed on either side of a scale, the way forms are placed in a composition will establish whether it is balanced. Two duplicate forms that are evenly spaced will necessarily balance one another (12-5). A small, dark form on one side of a composition may balance a larger, lighter form on the other side (12-6). A group of small forms on one side may also balance a single,

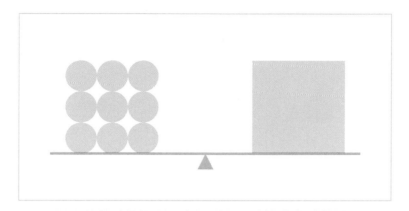

FIGURE 12-7

SYMMETRY

FIGURE 12-8

larger form on the other side (12-7). The possibilities for balancing the forms within a composition are limitless.

In most situations, a sense of balance is desired in a design. There are two types of balance that can be achieved in a composition: symmetrical balance and asymmetrical balance. **Symmetrical balance**, sometimes referred to as formal balance, is achieved when one side of a composition is a mirror image of the other side (12-8). Each form that

SYMMETRICAL BALANCE. Lisa Beck, To Everything (impossible), 2009. Acrylic on canvas, two panels, 72 x 96 inches (182.3 x 243.8), each panel 72 x 48 inches (182.3 x 121.9 cm). © *Lisa Beck. Courtesy Feature Inc., New York.*

is placed in the composition has a duplicate form on the opposite side of the composition. Because there is an exact correspondence between the elements on each side of the composition, the visual weight is evenly distributed and the composition will be balanced. Symmetrical balance tends to create a feeling of order and stability. A special type of symmetrical balance is **radial balance**, where repeated elements of a design are organized around a point. In radial balance, forms seem to radiate outward in circles from a central location with each form having a matching partner on the opposite side of the circle (12-9). Compositions with radial balance tend to have a greater sense of motion, and the circular arrangement creates a focal point at the center of that radiation.

RADIAL BALANCE. Philip Taaffe, *Unit of Direction No. 2 with Jurassic Flint Sponges,* 2008. Mixed media on linen, 96 x 96 inches (243.8 x 243.8 cm). © *Philip Taaffe. Photography by Robert McKeever. Courtesy Gagosian Gallery, New York.*

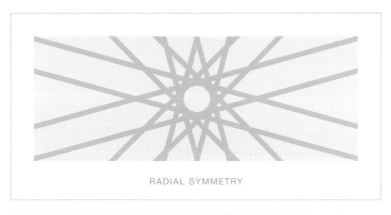

RADIAL SYMMETRY

FIGURE 12-9

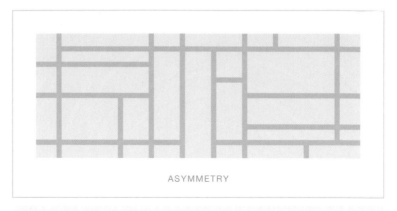

ASYMMETRY

FIGURE 12-10

In comparison, designs with asymmetrical balance are not as rigidly organized. **Asymmetrical balance**, often referred to as informal balance, is achieved through a less structured arrangement of forms. The visual weight of one side of the composition is roughly equal to the other side, but the two halves are not direct reflections of one another (12-10). Asymmetrical balance is a more complex kind of balance, relying on compound interactions between dissimilar forms. Compositions with asymmetrical balance tend to be more dynamic and often have a greater sense of energy than symmetrically balanced arrangements.

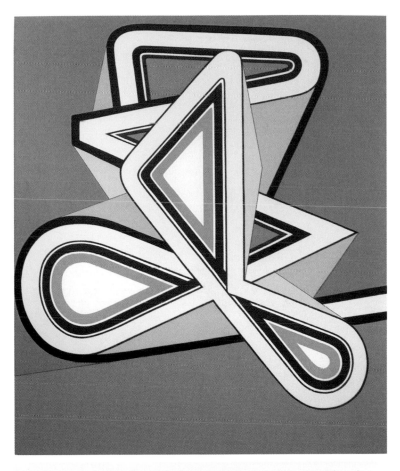

ASYMMETRICAL BALANCE. Bart Exposito, Earth 3, 2006. Acrylic and marker on canvas, 84 x 72 inches (213.4 x 182.9 cm). © *Bart Exposito, 2006. Courtesy Saatchi Gallery, London.*

EMPHASIS

13

13 EMPHASIS

Unless a design consists of a single element repeated uniformly, certain areas of the composition will necessarily stand forward and gain the viewer's attention. As soon as contrast is introduced in a design, particular elements become emphasized and assume greater visual importance in the composition. Through the use of **emphasis**, a designer can guide a viewer's gaze over a composition by providing visual cues to the relative importance of its elements.

A specific element or area in a composition that is emphasized is known as a **focal point** or **center of interest**. As the term implies, a focal point is a specific location in a composition where the viewer's attention is focused (13-1). A focal point is differentiated or highlighted from its surroundings in some fashion and serves as an entry point for a viewer's consideration of a design. A composition may employ a single focal point, or it may utilize several (13-2). When multiple focal points are used, they may also have differing levels of emphasis or

FIGURE 13-1

FIGURE 13-2

FIGURE 13-3

visual importance (13-3). The number of focal points and their individual strength will direct the viewer's investigation of a design, from strong to weak.

There are many ways to create visual emphasis in a design. The use of contrast, the manipulation of size and quantity, and the use of line can all generate focal points in a composition. Perhaps the primary means for

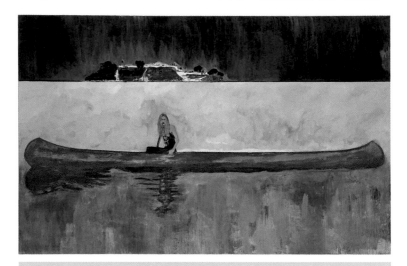

EMPHASIS THROUGH CONTRAST. Peter Doig, 100 Years ago (figure in canoe), 2001. Oil on canvas 90 x 141 inches (228.6 x 358.1 cm). © *Peter Doig. Courtesy Gavin Brown's Enterprise, New York.*

creating emphasis in a design is through the use of contrast (13-4). An area of high contrast in a composition calls attention to itself and creates visual emphasis. A strong degree of contrast in shape, size, color, or texture can generate a focal point. On the other hand, areas of low contrast will appear subdued and less visually important.

FIGURE 13-5

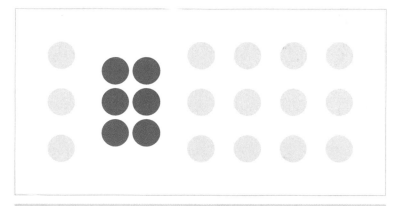

FIGURE 13-6

In addition to contrast, the individual size of a compositional element will also affect the amount of attention it receives. Forms that are large in size tend to take on greater visual emphasis in composition, while smaller forms appear less visually important (13-5). The quantity and concentration of forms in a design will additionally affect their level of emphasis. If a number of forms are collected in one area of a composition, then that area will become emphasized (13-6). But the converse is also true. If a single element appears to be isolated from the other elements

EMPHASIS THROUGH SIZE. Craig Kalpakijan, **Shard,** 2007. Inkjet print, 32 x 43 inches (81.3 x 109.2 cm). © *Craig Kalpakijan. Courtesy of the artist.*

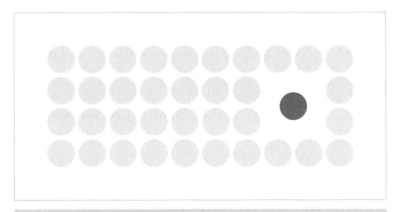

FIGURE 13-7

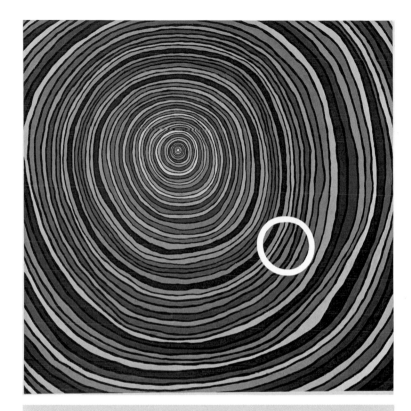

EMPHASIS THROUGH ISOLATION. Mamie Holst, Landscape Before Dying (Toward Exiting #8), 2008. Acrylic paint on canvas, 71 x 71 inches (180.3 x 180.3 cm). © *Mamie Holst. Courtesy Feature Inc., New York.*

of a design, it too will stand out and create a focal point (13-7). Both areas of concentration and elements in isolation become emphasized in a composition when compared to an even distribution of forms.

The use of line can also focus a viewer's attention to a specific location in a composition. Because lines imply an inherent sense of direction, our eyes tend to follow the paths they create. This allows a designer to signify areas of interest through line. A designer can use visible lines in a composition that physically point to an area of emphasis,

FIGURE 13-8

FIGURE 13-9

although this technique can appear blatant (13-8). Implied lines, such as edges of forms or a linear progression of elements, can also be used to guide the viewer's attention and to indicate areas of visual importance (13-9).

MOVEMENT

14

14 MOVEMENT

When examining a design, a viewer's eye will move across the picture plane, following progressions of form and stopping at points of emphasis. A viewer will find a starting position in the design and follow a path of exploration until the entire composition has been examined. A designer can predict and control this sense of movement through the deliberate placement of compositional elements in a design. There are two kinds of movement a designer can generate in a composition: visual movement and implied movement. **Visual movement**, also known as **rhythm**, occurs as the viewer's gaze travels across a composition investigating its content. **Implied movement** occurs when the elements of a composition have the illusion of being in motion themselves.

While rhythm is a term most often associated with music, it is also a concept that can be applied to design. Instead of musical notes and rests creating an audible sequence of movement, a design uses form and space to create a visual sequence of movement. Visual rhythm primarily depends on the use of repetition. This repetition can occur through the qualities of shape, size, color, or texture. Recurring areas of similarity, contrast, or emphasis can additionally generate a sense of rhythm. The use of repetition establishes visual accents that lead a viewer's eye through the composition (14-1).

The rhythm of a design is characterized by the placement of its elements and the direction and speed of their visual movement. Elements can travel laterally across a composition, with a progression to the left, right, top, or bottom of the picture plane. Elements can also travel spatially within a composition, with a progression forwards or backwards

FIGURE 14-1

FIGURE 14-2

through the implied depth of the design (14-2). In addition, the overall rhythm of a design can be fast or slow, regular or irregular, uniform or progressive. Repeated elements that are placed close together have a slow rhythm, while wide intervals suggest a faster visual pace (14-3). Recurring elements that follow an orderly progression have a regular visual tempo, while a more haphazard arrangement suggests an

FIGURE 14-3

FIGURE 14-4

irregular rhythm (14-4). Repeated elements that are evenly spaced apart have a uniform rhythm, while a series of increasing or decreasing gaps suggests a variation in speed (14-5).

In addition to guiding a viewer's eyes over a composition, a designer can also generate a sense of implied movement within a design. Similar to depth or volume, creating a sense of physical motion is always illusory, because a two-dimensional composition is inherently static and does not change over time. But while the elements of a design cannot be

FIGURE 14-5

FIGURE 14-6

In actual motion, it is possible to give them the illusion of movement. There are two primary methods for creating implied motion in a design: sequential change and blurring.

Implied movement can be generated in a design by sequentially repeating a form while simultaneously introducing a gradual change. This change can be in any of the form's qualities, but it must be steady and uniform. By making slight, successive alterations to a repeated form, a sense of gradation is created with the form appearing to transform over time (14-6).

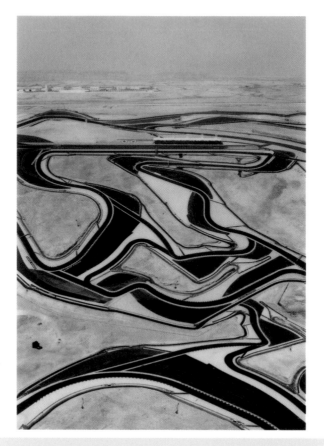

VISUAL MOVEMENT. Andreas Gursky (b. 1955), **Bahrain I,** 2005. Chromogenic color print, 9' 10 7/8" x 7' 2 1/2" (301.9 x 219.7 cm). © 2011 Andreas Gursky/Artists Rights Society (ARS), New York/VG Bild-Kunst, Bonn. Acquired in honor of Robert B. Menschel through the generosity of Agnes Gund, Marie-Josée and Henry R. Kravis, Ronald S. and Jo Carole Lauder, and the Speyer Family Foundation. The Museum of Modern Art, New York, NY, USA. Digital Image © The Museum of Modern Art/Licensed by SCALA/Art Resource, NY.

Blurring the edges of forms or reducing their apparent focus can also create an illusion of movement in a design. Because we are unable to clearly recognize objects that pass through our field of vision at high speeds, the use of blurring in a design can suggest that an element is in fast motion. The direction an element is blurred will also imply the direction in which it is moving (14-7).

IMPLIED MOVEMENT. Chris Hanson and Hendrika Sonnenberg, Untitled, 2003. Ink and synthetic polymer paint on synthetic polymer sheet, 13 1/4 x 14 1/2 inches (33.7 x 36.8 cm). © 2011 Chris Hanson and Hendrika Sonnenberg. The Judith Rothschild Foundation Contemporary Drawings Collection Gift. The Museum of Modern Art, New York, NY, USA. Digital Image © The Museum of Modern Art/ Licensed by SCALA/Art Resource, NY.

FIGURE 14-7

UNITY

15

15 UNITY

The final goal in the assembly of a composition is to create an overall sense of unity, where all of the elements are in accord and none seem out of place. When a composition exists as a complete and coherent whole, and becomes greater than the sum of its parts, it is in **unity**. If a composition feels splintered and appears to consist of unrelated elements, then it is lacking in unity. There are no fixed rules for achieving unity, but a designer should always strive towards the goal of unification when developing a composition. The artist Paul Cezanne once stated:

> *There mustn't be a single slack link, a single gap through which the emotion, the light, the truth can escape. I advance all of my canvas at one time, if you see what I mean. And in the same movement, with the same conviction, I approach all the scattered pieces . . .*[*]

In this sense, achieving unity is bringing together that which is scattered. Careful attention should be given to all aspects of a design in an attempt to bring them into accord with one another. The format of a design, its elements, their qualities, and their interactions will all have bearing on whether a sense of unity is achieved.

Because most designs consist of many elements with differing properties, achieving unity requires attaining balance in the variety of a design. The use of contrast in a composition generates a sense of variety and lends visual interest to a design. But contrast and variety are generally in opposition to unity. The greater the visual difference between two

[*] Joachim Gasquet, *Joachim Gasquet's Cezanne: A Memoir With Conversations*, trans. Christopher Pemberton. London: Thames & Hudson. 1991.

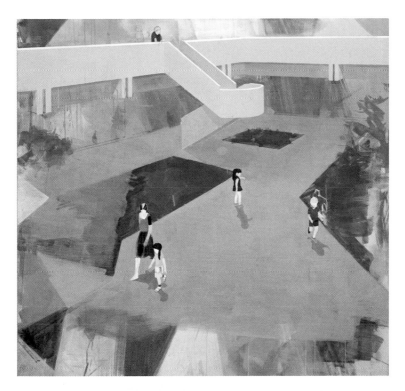

UNITY. Thomas Eggerer, *Atrium*, 2003. Acrylic/canvas, 60 x 63 inches (152.4 x 160 cm). *© Thomas Eggerer. Photography by Fredrik Nilsen. Courtesy Richard Telles Fine Art, Los Angeles.*

forms, the less they appear to belong together. So a designer must seek a point of equilibrium, using enough variety to engage the viewer, while not damaging the overall unity of the design. In finding this balance, a designer must be able to create a composition that is both visually appealing and unified. By bringing together a variety of elements, each with differing properties and characteristics, a designer has the ability to create a unified and harmonious design that yields a greater impact than the simple collection of its components.

Achromatic Achromatic colors are colors with no saturation and no discernible hue quality (48).

Aerial Perspective Aerial perspective is a visual phenomenon where distant objects are seen through a layer of air or atmosphere, making them appear softer and more diffuse to the viewer. Also known as Atmospheric Perspective (74).

Analogous A group of colors that utilizes multiple but similar hues is considered analogous (40).

Asymmetrical Balance Asymmetrical balance is achieved when the visual weight of one side of a composition is roughly equal to the other side, but the two halves are not direct reflections of one another (106).

Atmospheric Perspective See Aerial Perspective (74).

Background See Negative Area (64).

Balance The overall balance of a design is determined by the distribution of visual weight within the composition (102).

Center of Interest See Focal Point (110).

Chroma See Saturation (46).

Chromatic Colors that have some noticeable degree of saturation are considered chromatic (48).

Closure The principle of closure states that a viewer will perceive completeness in shape, even when visual information is missing (26).

Color A color is defined by a unique combination of hue, value, and saturation (38).

Common Fate The principle of common fate states that elements moving in the same direction are seen as belonging together (88).

Complementary Two colors that exhibit the maximum difference in hue are considered to be complementary (41).

Composition A composition is the arrangement of the individual visual elements that comprise a design (62).

Continuity The principle of continuity states that elements tend to be grouped together when they are in alignment with one another (88).

Contour Line A line that circumscribes the outermost limits of a shape is called a contour line. Also known as Outline (17).

Contrast Contrast in design is the use of dissimilar elements or properties to create visual distinction (92).

Cross-Hatching When repeated lines intersect one another to generate the impression of a textured gray area, the effect is known as cross-hatching (21).

Depth See Space (68).

Design A design is the conclusion of a plan, a resulting product with a given purpose (2).

Emphasis Emphasis occurs when elements assume greater visual importance in a composition (110).

Familiarity The principle of familiarity states that elements whose combination renders a meaningful or familiar image will appear as belonging together (89).

Figure See Positive Shape (63).

Figure-Ground Figure-ground refers to the relationship between the positive and negative shapes of a design (65).

Focal Point A focal point is a specific element or area in a composition that is emphasized. Also known as Center of Interest (110).

Foreground See Positive Shape (63).

Form See Shape (24).

Format The format of a design is the defined space where the design elements are placed and arranged (6).

Frame The outer boundary or edge of a picture plane is known as its frame (10).

Geometric Shape A shape that is mechanical or mathematical in nature is considered to be geometric (26).

Gestalt Principles Gestalt principles help explain how visual input is organized into perceptual groups (86).

Good Figure The principle of good figure states that elements tend to be grouped so the resulting image is as simple as possible (89).

Ground See Negative Area (64).

Hatching When repeated lines parallel one another to generate the impression of a textured gray area, the effect is known as hatching (21).

High-Key A design in which light values dominate is said to be high-key (45).

Horizon Line In linear perspective, the horizon line runs horizontally across the picture plane and corresponds to the eye level of the viewer (77).

Hue Hue is the name assigned to a color in its purest form (39).

Implied Movement Implied movement occurs when the elements of a composition have the illusion of being in physical motion (118).

Implied Texture Implied texture is a two-dimensional texture that generates the impression of a three-dimensional surface (56).

Intensity See Saturation (46).

Intermediate-Key A design in which mid-range values dominate is said to be intermediate-key (45).

Intersection The intersection of overlapping forms leaves behind the area that is common to the forms (86).

Landscape Format A rectangular format with a horizontal orientation is known as a landscape format (7).

Line A line is a simple form that is relatively narrow in width and prominent in length (13).

Line Weight The width of a line is known as its line weight and is often described as heavy (thick) or light (thin) (14).

Linear Perspective Linear perspective is a mechanical system for representing three-dimensional objects on a two-dimensional surface (76).

Low-Key A design in which dark values dominate is said to be low-key (45).

Monochromatic A group of colors that is restricted to a single hue is defined as monochromatic (40).

Negative Area When an area of a composition appears empty or unoccupied, that area is considered to be negative. Also known as Ground or Background (64).

Neutral Neutral colors are defined as colors with limited saturation (48).

Optical Mixing Optical mixing occurs when small areas of color are placed close together and mix visually to form a new color (53).

Organic Shape A shape derived from forms found in nature is considered to be organic (29).

Outline See Contour Line (18).

Overlapping Overlapping occurs when one form partially passes over another and appears to be residing on top of it (85).

Pattern A pattern is the systematic recurrence of a motif (58).

Picture Plane The picture plane is the flat surface on which a two-dimensional design is executed (9).

Point A point is a simple form that has roughly equal length and width and is relatively small in size (12).

Portrait Format A rectangular format with a vertical orientation is known as a portrait format (6).

Positive Shape When an area of a composition appears occupied, that area is considered to have positive shape. Also known as Figure or Foreground (63).

Proportion Proportion refers to the size relationships between various elements of a design (33).

Proximity The principle of proximity states that elements are grouped together visually when they are positioned near one another (86).

Radial Balance In radial balance, forms radiate outward in circles from a central location with each form having a matching partner on the opposite side of the circle (104).

Rhythm See Visual Movement (118).

Saturation Saturation is the relative purity or strength of a color. Also known as Intensity or Chroma (46).

Scale See Size (32).

Shade A shade is a color variation created by adding black to a hue (44).

Shape A shape is a closed two-dimensional figure with a discrete length and width. Also known as Form (24).

Similarity The principle of similarity states that objects with similar visual characteristics will be seen as belonging together (88).

Simultaneous Contrast Simultaneous contrast is the color phenomenon where similarities between neighboring colors are reduced and their differences amplified (49).

Size Size refers to the physical dimensions or magnitude of an object. Also known as Scale (32).

Space In two-dimensional design, an illusion of space occurs when the composition suggests the existence of a third dimension behind the picture plane. Also known as Depth (68).

Structure The structure of a composition is the underlying framework that governs the arrangement and positioning of its forms (62).

Subtraction The subtraction of overlapping forms yields a merged form where the area common to the forms is removed, leaving a hole (85).

Symmetrical Balance Symmetrical balance is achieved when one side of a composition is a mirror image of the other side (103).

Texture Texture is defined as the physical surface quality of an object (56).

Tint A tint is a color variation created by adding white to a hue (44).

Tonal Key The tonal key of a design is its overall tendency towards light, medium, or dark values (44).

Tonal Range The tonal range of a design is the amount of variety between the values of its colors (45).

Tone A tone is a color variation created by adding gray to a hue (44).

Transparency Transparency occurs when two forms overlap but the viewer is able to see through the overriding form to some degree, making the form beneath partially visible (85).

Union The union of overlapping forms creates a single, larger form by merging the individual forms together (85).

Unity When a composition exists as a complete and coherent whole, and becomes greater than the sum of its parts, it is in unity (126).

Value Value is the relative lightness or darkness of a color (41).

Vanishing Point In linear perspective, a vanishing point governs the convergence of receding lines in the composition (78).

Visual Movement Visual movement occurs when a viewer's gaze travels across a composition to investigate its content. Also known as Rhythm (118).

Visual Texture Visual texture is a two-dimensional texture that appeals solely to our sense of sight and does not evoke a tactile sensation (58).

Volume In two-dimensional design, an object has an illusion of volume when it appears to fill a three-dimensional space in the composition (80).